Scrapbooks

Make your scrapbook pages more personal by using your own art,

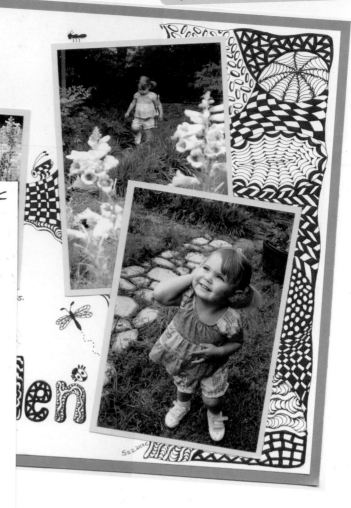

Draw Zentangle alphabet letters to spell a title or your child's name.

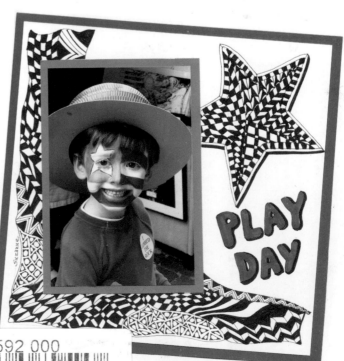

Just for fun, Zentangle on the edges of pages. Or create a design in the center.

Add small photos and me between the sections of a Zenta

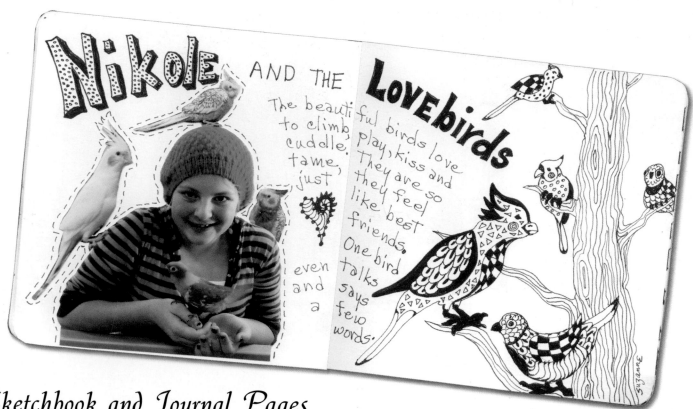

Sketchbook and Journal Pages

Zentangle is a wonderful way to embellish your pages.

You may want to begin with small photos or scraps of memorabilia (ticket stubs, gum wrappers, a clipping) then use memories of the occasion to embellish the pages with patterns. By adding designs, drawings and writing with your own hand, your sketchbook or journal will be totally personal.

This year, I plan to add at least one Tangle section to every page.

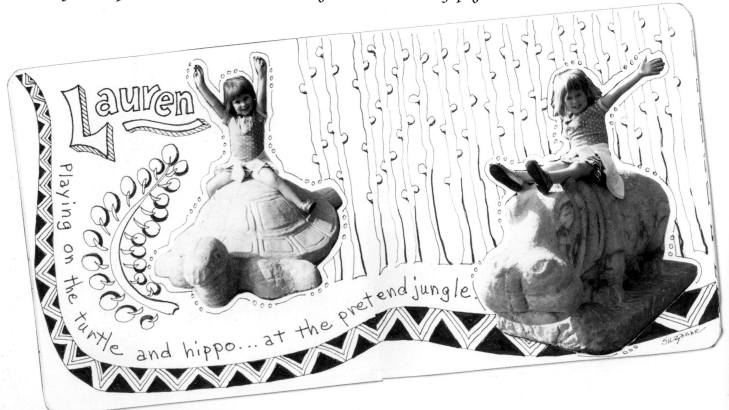

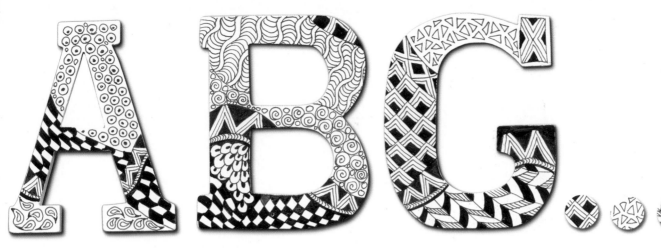

ABC...

Alphabet, Names, Initials, Titles and Words...

Trace or draw block letters. They could be a name, a title, initials or a word.

Draw sections within the letters, then add a Tangle pattern in each section.

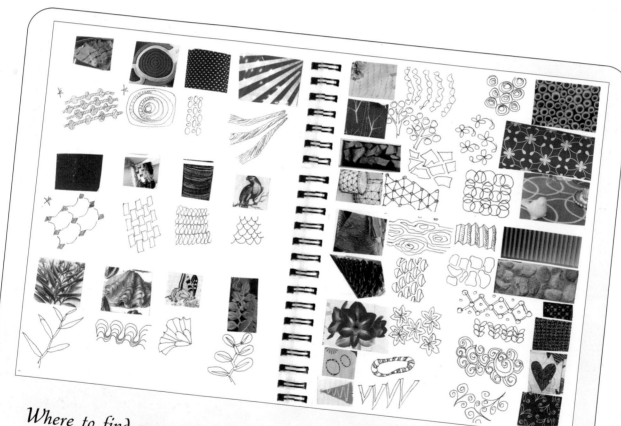

Where to find more patterns...

Start with the patterns in this book. Then check out more books. Additional designs can also be found at zentangle.com and at blog.suzannemcneill.com.

Also look at quilts, books, furniture, nature, illustrations and the bottoms of sport shoes ... wonderful patterns and designs are everywhere.

I clip snippets out of magazines and advertisements, then paste them in a notebook to use as inspiration for new Tangle patterns.

Traditional Zentangle...

A very simple process is part of every traditional Zentangle.

1. Make a dot in each corner of your paper tile with a pencil. Connect the dots to form a basic border.
2. Draw guideline "strings" with the pencil. The shape can be a zigzag, swirl, X, circle or just about anything that divides the area into sections.

 It represents the "golden thread" that connects all the patterns and events that run through life.

 The lines will not be erased but become part of the design.
3. Use a black pen to draw Tangle patterns into each section formed by the "string".
4. Rotate the paper tile as you fill each section with a pattern.

How to Get Started... *from the 'Zentangle Basics' book*

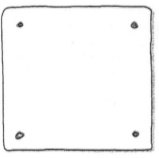 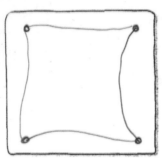 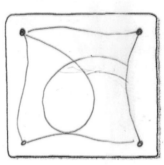 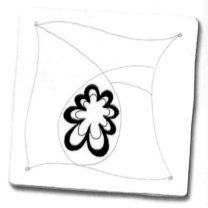

1. Use a pencil to make a dot in each corner.

2. Connect the dots with the pencil.

3. Draw a "string" with the pencil as a guide line.
 Try a Z zigzag, a loop, an X 'X' or a swirl.

4. Switch to a pen and draw tangle patterns in each section formed by the "string".
 When you cross a line, change the pattern. It is OK to leave some sections blank.

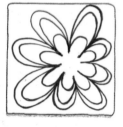 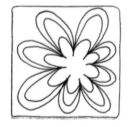

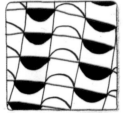 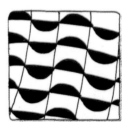

Each Tangle is a unique artistic design and there are hundreds of variations. Start with basic patterns, then create your own.

With Zentangle, no eraser is needed. Just as in life, we cannot erase events and mistakes. Instead, we must build upon them and make improvements from any event.

Life is a building process. All events and experiences are incorporated into our learning process and into our life patterns.

Ribbon Bow

1. Make 8 dots in a circle, close to the center of any section.
2. Draw a curved line to connect 2 dots. Draw a second curved line. Draw a third curved line close to the center.
3. Draw additional curved lines to connect all 8 dots.
Optional: Color the ribbons with black.

Wiggle Waves

1. Draw vertical lines and horizontal lines to form a grid.
2. Make curved lines under each line in every other row.
3. Color the curved spaces with black.
4. Make curved lines over each line in the remaining rows.
5. Color the spaces with black.

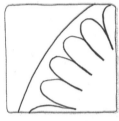
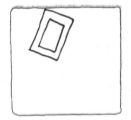
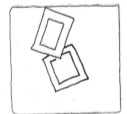
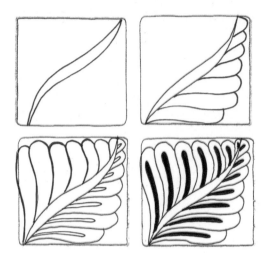

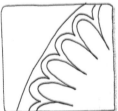
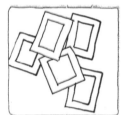

Fan Border

1. Draw curved lines with long points on one side of a line or an outside border.
2. Draw a halo line inside of the long points.

Optional: Add additional halo lines if desired.

Rectangles

1. Draw a rectangle shape. Draw an interior rectangle shape.
2. Draw a second rectangle. Stop the line so it looks like this rectangle is underneath the first rectangle. Draw an interior rectangle shape.
3. Draw additional rectangles, stopping so the lines look like these rectangles are underneath the first rectangles. Draw interior rectangle shapes.
4. Fill the entire section with rectangles.

Frond

1. Draw 2 lines to form a stem, the lines should touch at each end.
2. Draw a small curved line at one end on the right side. Draw additional curved lines, increasing the size to fit the section.
3. Draw curved lines on the left side.
4. Draw a long vein in each space. Color the veins with black.

Optional...
Shading Your Zentangle

Shading adds a touch of dimension.

1. Use the side of your pencil to gently color areas and details gray.
2. Rub the pencil areas with a 'paper stump' to blend the gray.

Note: Use shading sparingly. Be sure to leave white sections white.

Where to add shading...

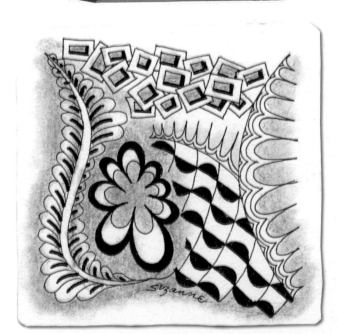

Inside of the Ribbon Bow

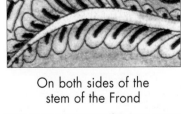

On both sides of the stem of the Frond

In each background space of the Rectangles

On the outside of the Fan Border

Use a pencil to add shading and use a 'paper stump' to rub the pencil areas to smudge, soften and blend the gray shadows.

Add shading along the right edge and the bottom of your finished shape. Make the shading about 1/8" wide, to "raise" tangles off the page.

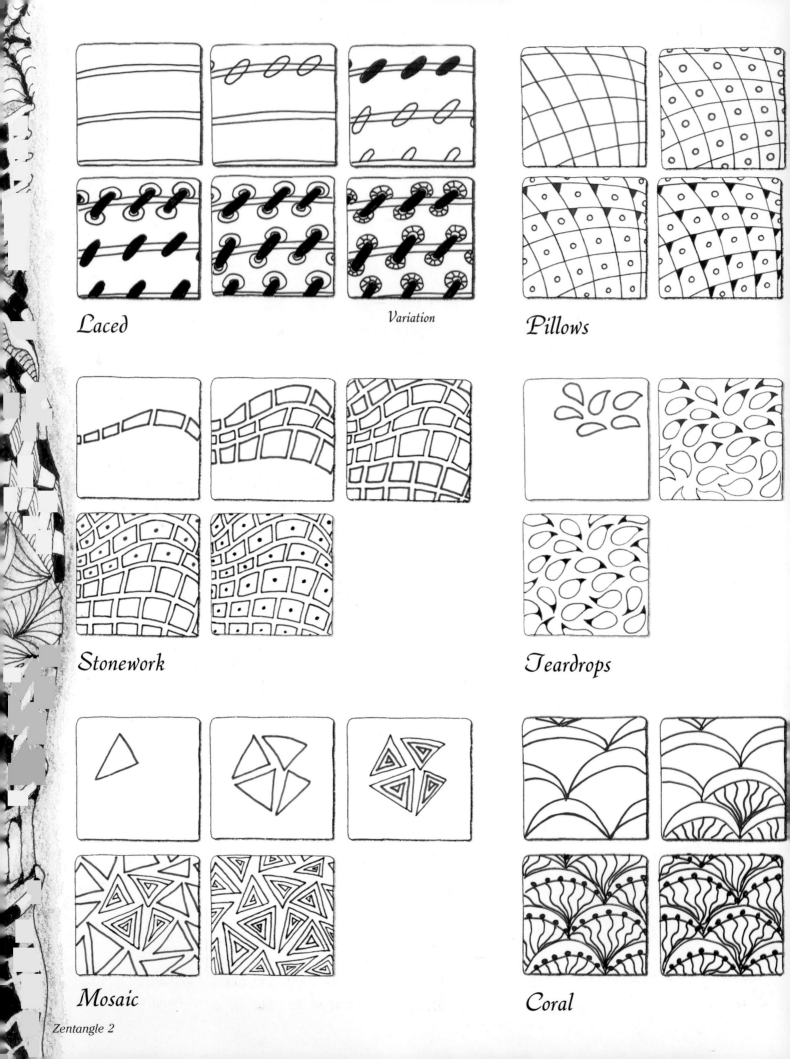

Laced

Variation

Pillows

Stonework

Teardrops

Mosaic

Coral

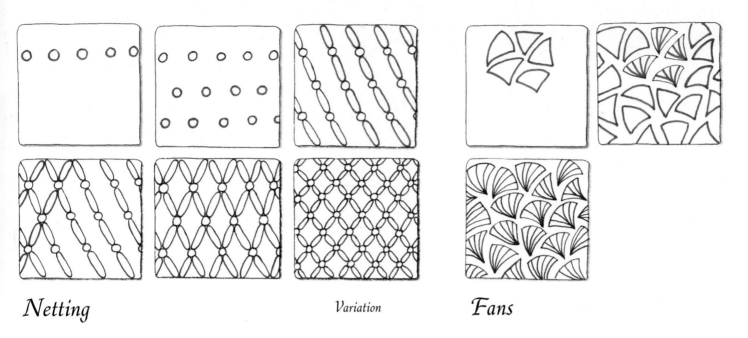

Netting

Variation

Fans

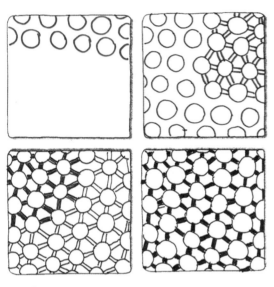

Networking

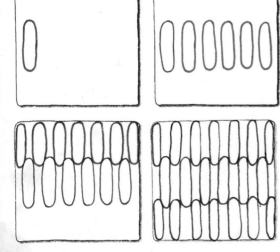

Stacks

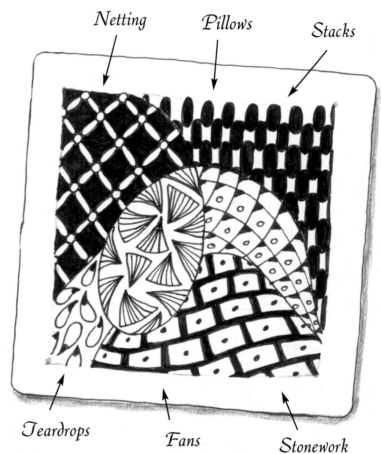

Netting Pillows Stacks

Teardrops Fans Stonework

Zen Personal

Scrapbookers are drawn into Zentangle because it is uniquely personal. The stories are your own. The pages are crafted by your hand using your interpretation of events.

Zentangle is particularly appealing because each tangle is as unique as its artist. Even if two people use the same tangle design, no two completed tangles are the same.

Each creation is as personal as your fingerprint.

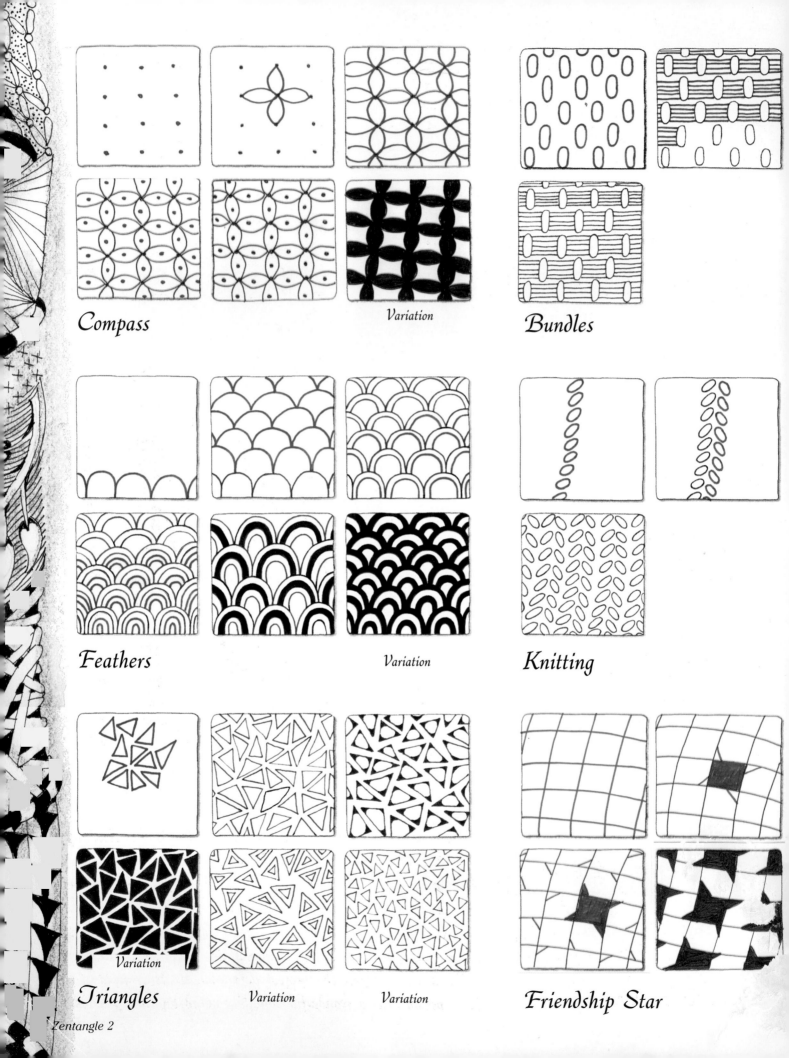

Compass

Variation

Bundles

Feathers

Variation

Knitting

Triangles

Variation

Variation

Variation

Friendship Star

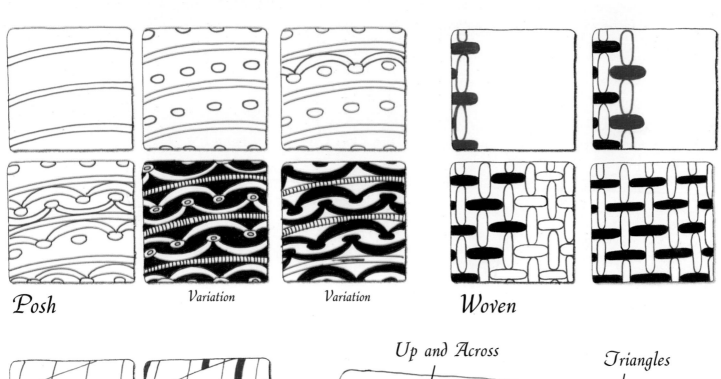

Posh *Variation* *Variation* **Woven**

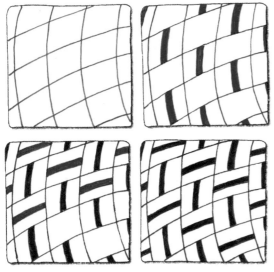

Up and Across

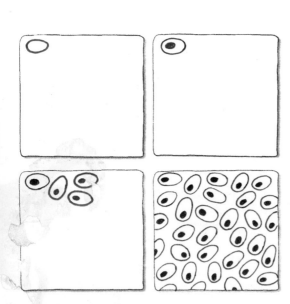

Black Eyed Peas

Up and Across *Triangles*

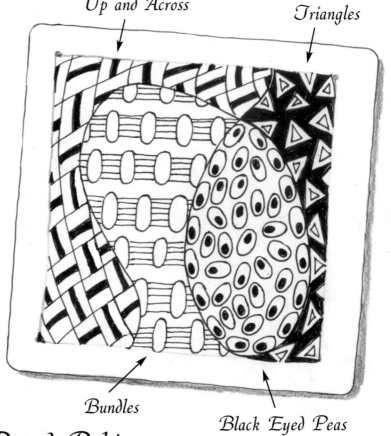

Bundles *Black Eyed Peas*

Round Robins

Looking for something adventurous? Consider a Zentangle exchange where you give a group your page and photos and each member adds something like a border, title, embellishment or journaling box. Because Zentangle is done in steps, it can be finished at a crop, party, or social hour. It's really fun to start, then pass the designs from left to right, with everyone doing a step. When the project gets back to its originator, each person has a wonderful collage created by their friends.

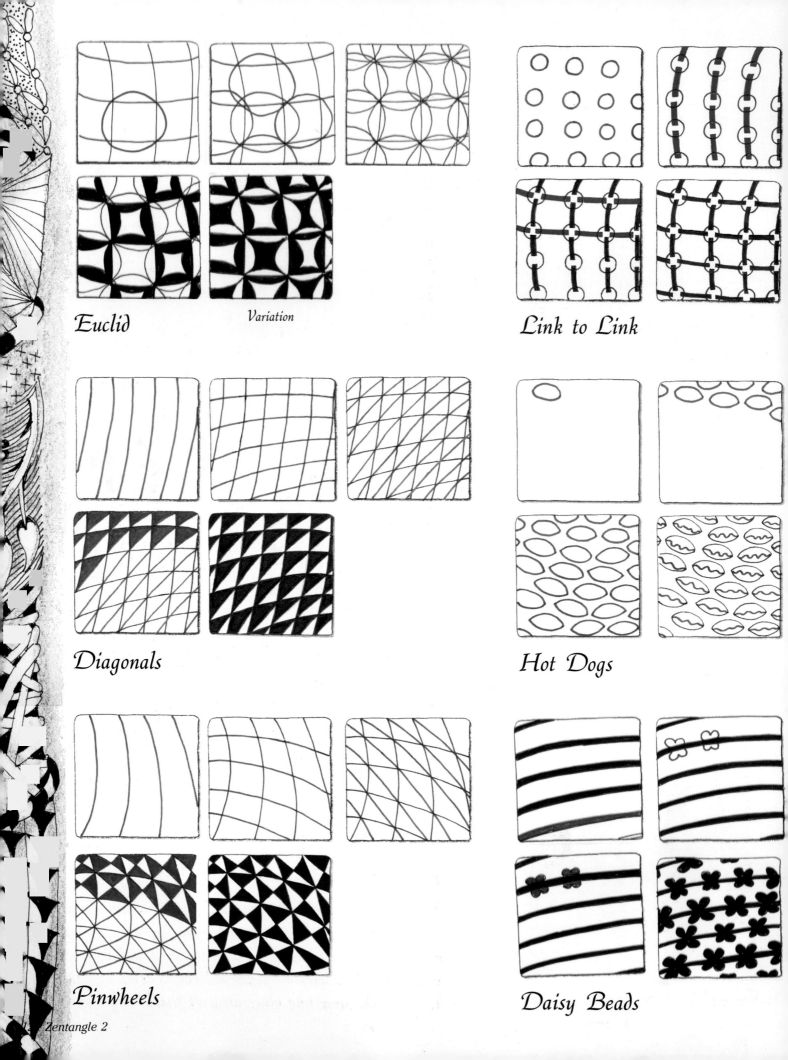

Euclid

Variation

Link to Link

Diagonals

Hot Dogs

Pinwheels

Daisy Beads

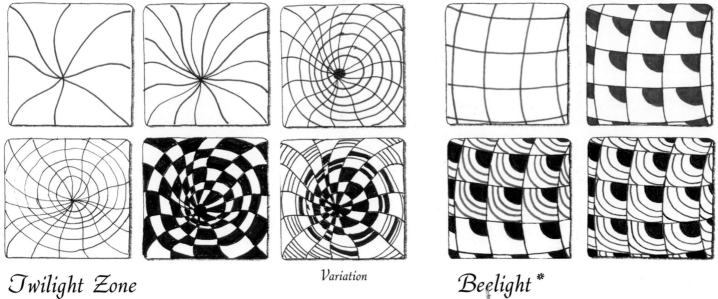

Twilight Zone

Variation

Beelight *
*original Zentangle design

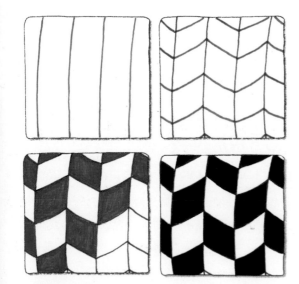

Black Box

Jonqal *
*original Zentangle design

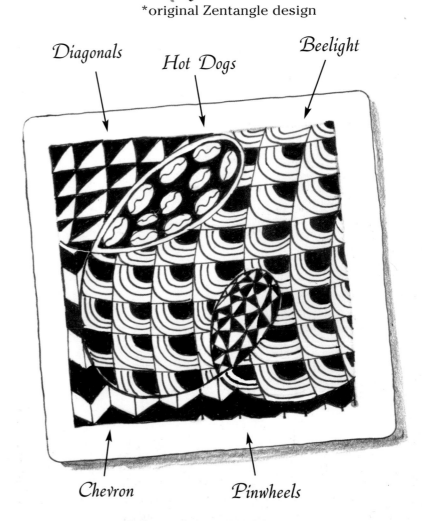

Diagonals

Hot Dogs

Beelight

Chevron

Pinwheels

Organize a 'Club Tangle'

Enthusiastic 'Tanglers' who have taken the introductory class often meet regularly to share tangle creations and learn about new patterns. Clubs form a camaraderie and members show how to use tangles on pages and cards. This infectious excitement spills over into other areas of friendship.

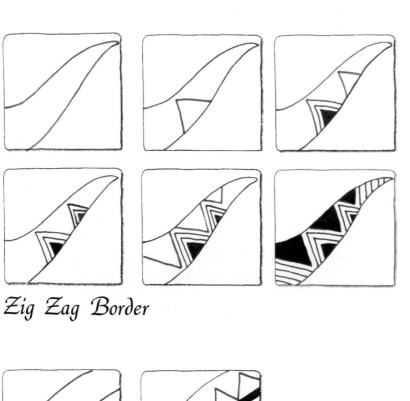

Zig Zag Border

Wavy Border

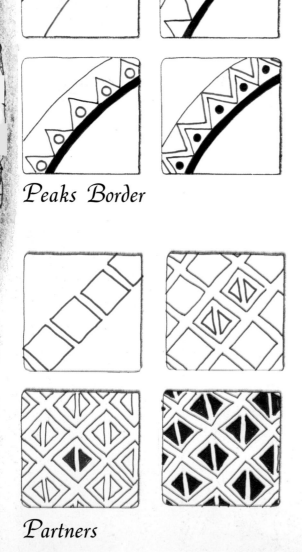

Peaks Border

Partners

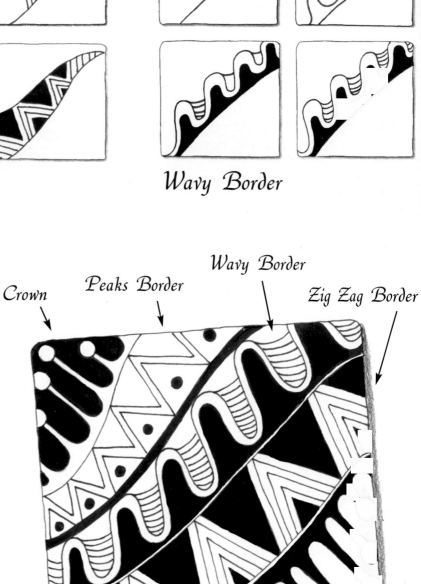

Crown

Peaks Border

Wavy Border

Zig Zag Border

Crown Border

Where to use Borders

The first place to use border Tangles is as an accent around the edge of a large design.

You can also run a parallel 'string' in selected areas of your piece and add a border Tangle between the lines to separate sections.

Or use multiple borders to fill a 'tile'.

Sea Weed Border

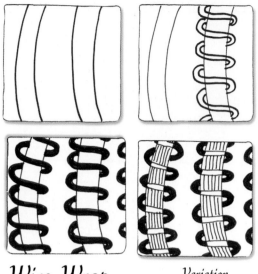

Wire Wrap Variation

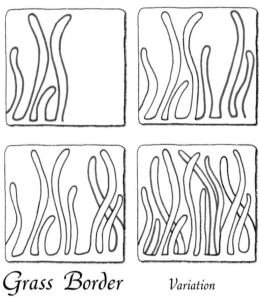

Grass Border Variation

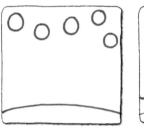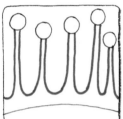

Crown Border

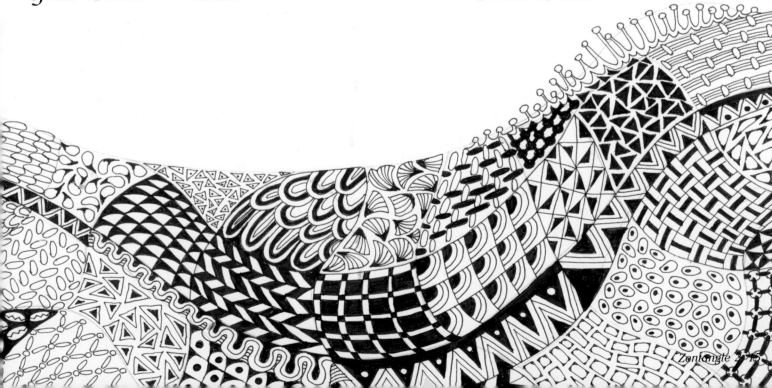

Design Tips

Traditional Zentangle designs are non-objective and have no recognizable image. The 'string' divides the sections.

It is also fun to use the process and include a 'string' to draw the outline of a subject. Fill in the sections with Tangles.

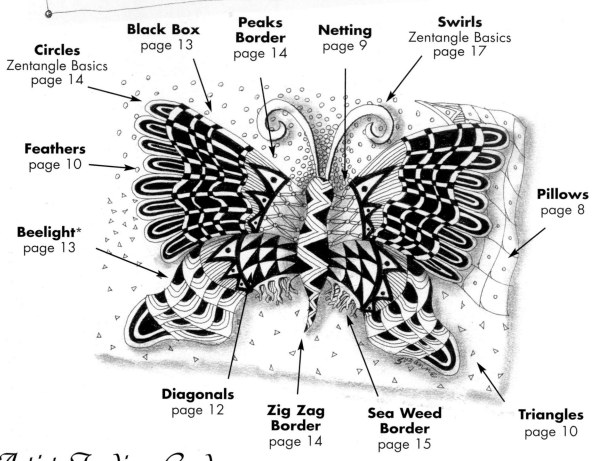

Circles
Zentangle Basics
page 14

Black Box
page 13

Peaks Border
page 14

Netting
page 9

Swirls
Zentangle Basics
page 17

Feathers
page 10

Beelight*
page 13

Diagonals
page 12

Zig Zag Border
page 14

Sea Weed Border
page 15

Triangles
page 10

Pillows
page 8

Be sure to practice so you are familiar with many Tangle patterns.

Refer to coloring books and the images on these pages for ideas.

Artist Trading Cards

*original Zentangle design

ATCs are fun to share with friends. Draw designs on a 2½" x 3½" piece of cardstock. Sign your name and date on the back, then trade the cards with friends.

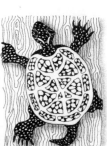
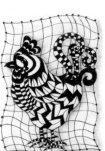
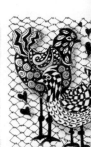

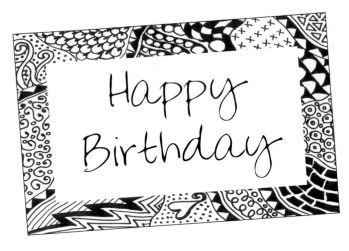

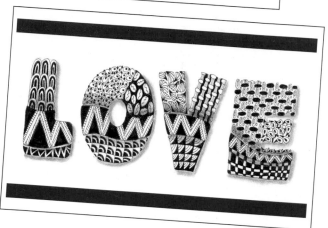

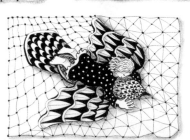

Postcards

For only a few pennies, it is fun and easy to send small drawings through the mail to share with friends.

Draw designs on a 4" x 6" piece of cardstock.

Write an address, a message, and your name on the back. Set up a 'swap' to trade postcards with friends.

Ideas for Postcard and Greeting Card Designs

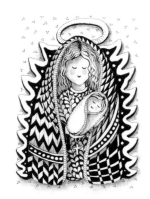
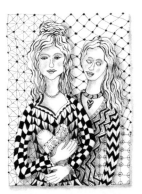
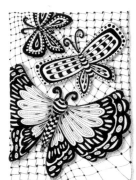

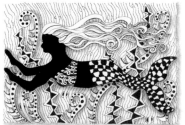

Ideas for Artist Trading Cards Designs

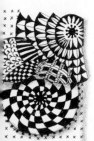
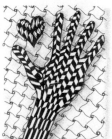
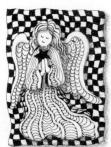
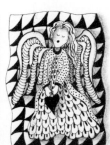
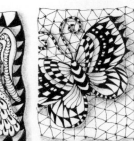
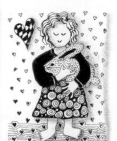

40 Fun Tangle Patterns...

 Ribbon Bow
page 6

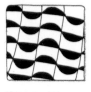 Wiggly Waves
page 6

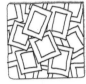 Rectangles
page 7

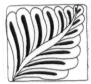 Frond
page 7

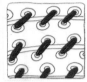 Laced
page 8

 Pillows
page 8

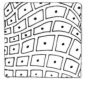 Stonework
page 8

 Teardrops
page 8

 Mosaic
page 8

 Coral
page 8

 Netting
page 9

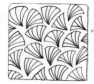 Fans
page 9

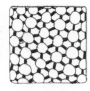 Networking
page 9

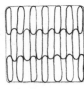 Stacks
page 9

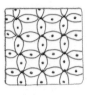 Compass
page 10

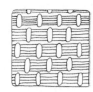 Bundles
page 10

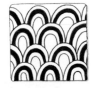 Feathers
page 10

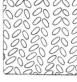 Knitting
page 10

 Triangles
page 10

 Friendship Star
page 10

 Posh
page 11

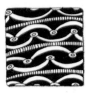 Woven
page 11

 Up and Across
page 11

 Black Eyed Peas
page 11

 Euclid
page 12

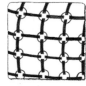 Link to Link
page 12

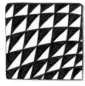 Diagonals
page 12

 Hot Dogs
page 12

 Pinwheels
page 12

 Daisy Beads
page 12

 Twilight Zone
page 13

 Beelight*
page 13

 Black Box
page 13

 Jonqal*
page 13

 Partners
page 14

 Zig Zag
Border
page 14

 Peaks
Border
page 14

 Wavy
Border
page 14

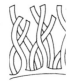 Sea Weed
Border
page 15

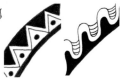 Wire
Wrap
page 15

 Grass
Border
page 15

Crown
Border
page 15

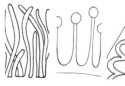 Fan
Border
page 7

*original Zentangle design

Suzanne McNeill

Suzanne is often known as "the Trendsetter" of arts and crafts. Dedicated to hands-on creativity, she constantly tests, experiments and invents something new and fun.

Suzanne is the woman behind **Design Originals**, a publishing company dedicated to all things fun and creative. She is a designer, artist, columnist, TV personality, publisher, art instructor, author and lover of everything hands-on.

Visit Suzanne at
blog.suzannemcneill.com
to see books, events and a 'Zentangle of the Week'

You'll find wonderful resources, a list of certified teachers and workshops, a fabulous gallery of inspiring projects, kits, supplies and tiles at **zentangle.com**

z e n t a n g l e ®

MANY THANKS to my staff for their cheerful help and wonderful ideas!
Kathy Mason • Kristy Krouse • Patty Williams